MEDITATIVE
Mandala Stones

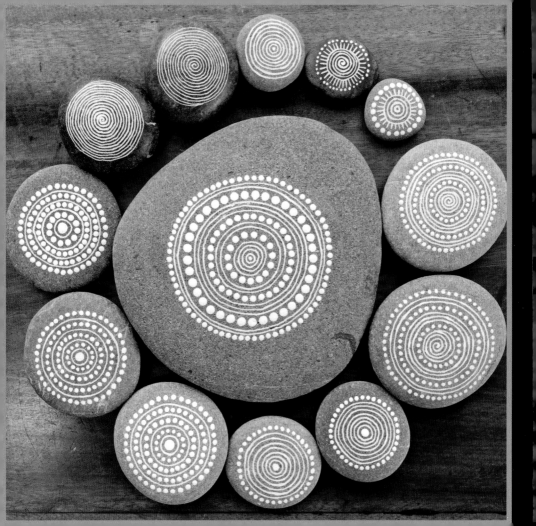

MEDITATIVE
Mandala Stones

create beautiful art and
find peace of mind

MARIA MERCEDES TRUJILLO ARANGO

ROCK
POINT
QUARTOKNOWS.COM

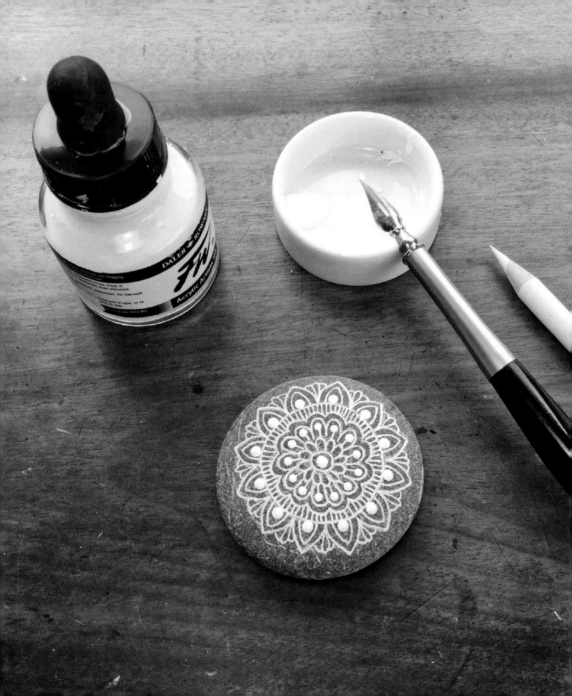

Contents

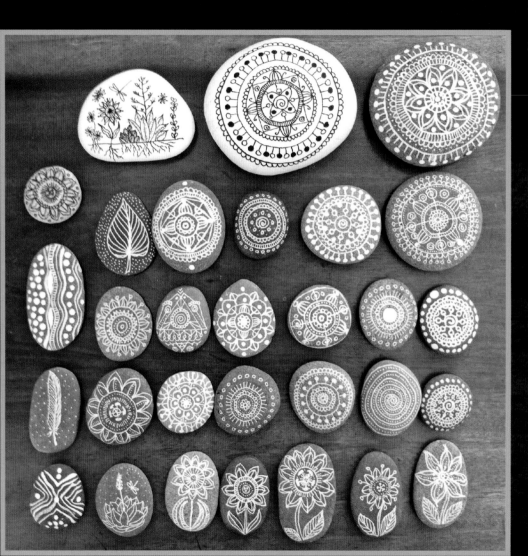

CARL JUNG, MY FAVORITE SEEKER OF THE SOUL, wrote in his book *Memories, Dreams, Reflections* that mandalas are "cryptograms concerning the state of the self," with the self being our whole being. At the beginning, when he started making mandalas, he could only understand little pieces, but he knew they were treasures written in code. He knew that the mandalas corresponded to something important, something central, and through his studies and interpretations of his personal mandalas, he acquired a "living conception" of what the self is, a concept that was key to his work. He said the mandala "corresponds to the microcosmic nature of the psyche." Each of us is a unit or monad, a whole, a microcosm. Our mandalas are like maps of our souls; they are representations of our "self" in a given moment, the moment when we create them.

Introduction

I have loved stones and mandalas for a long time. I started collecting stones when I was a little girl. They have always fascinated me, being old and new at the same time—old because they are millions of years old, and new to me, every time I discover one. Each one is unique. In October 2011, I started drawing and painting mandalas on stones that I had collected.

My fascination with mandalas started in 2000, just after the beginning of my artistic journey. I had moved to New Zealand for the first time and had stopped working as a physician specializing in psychiatry. I had plenty of time, so I started exploring creativity and art, first through embroidery and then through visual diaries.

I'm a little bit obsessive when I find something I like, so I started reading every book I could find about creativity and creative processes. I found Carl Jung's *Memories, Dreams, Reflections* as a reference in many of the books I read, and my logic told me I had to read it.

It's an autobiographical book he wrote in collaboration with Aniela Jaffé, in which he narrates parts of his life and experiences, framed in relation to the development of his own work. After reading the chapter "Confrontation with the Unconscious," where he narrates, among many other fascinating things, when he started drawing and painting mandalas and finding their meanings, I was mesmerized.

I started drawing mandalas in my journals. I also began studying their history, philosophy, and psychology and haven't stopped since. I still draw, paint, or embroider mandalas almost every day.

Many times when I make mandalas, I feel relaxed and connected with the cosmos, nature, and people, but most important, with my own self.

Sometimes when I make mandalas, I experience a similar feeling as when I'm practicing meditation; other times, I don't feel anything special except the pleasure of making them.

What Is a Mandala?

Mandala is a Sanskrit word and means "circle" in a broad sense, sometimes "magic circle" or "center." These circular motifs or patterns can be drawn, painted, carved, weaved, embroidered, or made with sand or other materials. They can also be architectural monuments, and they can even be danced.

In religion and philosophy, mandalas are representations of the cosmos, the universe, or God. In analytical psychology and according to Carl Jung, mandalas represent the self, the wholeness of the personality. Mandalas are found in different cultures and periods of our history, including the present. They can be divided into categories of collective or cultural mandalas and individual or personal mandalas.

Collective mandalas are the ones found in a culture, or in a spiritual or philosophical tradition. They are part of ceremonies and rituals; tools for meditation; and sacred representations of the cosmos, the universe, or God. Their patterns are predetermined, mostly unvarying, and precise.

There are many examples and types of collective mandalas around the world. In primitive religions there are dots, spirals, circles, concentric ripples, and sun wheels, and they can be found in many caves and on rocks, both carved and painted. Some sandpaintings, which are still painted by the Aborigine in Australia and the Navajo in healing ceremonies, are other examples of mandalas. Hindus have *yantras*, which are geometrical designs that don't include any figurative elements. *Kolams* and *rangoli* have different names and designs depending on the region; these are mandalas drawn every day by some women in India and other

Asian countries, outside their houses, with white and colored rice flour or chalk.

Mehndi, or the art of henna tattoos, is practiced in India and many other countries as an important part of the wedding ritual and includes lots of mandala designs. Buddhists have sand mandalas made by lamas. *Thangkas*, which are mandalas painted on silk, and *stupas*, which are temples, are constructed with plans in the form of mandalas. In Judaism, some details in synagogues, such as the domes, some windows, and the *kippah* (yarmulke or skullcap) the men wear, can be considered mandalas. In the Christian tradition, there are mandalas like the Celtic cross, the rose windows in churches, and also the halos of saints. Examples found in Islam are the geometrical rosettes and the Sufi dance of the dervishes. These are just some examples of mandalas around the world. There are many more, which would take more than one book to list and describe.

Individual mandalas are personal expressions of our psyche and are not related to any tradition or model. Although they can share common symbols, each one is unique to its creator. According to Carl Jung, they are like a map of our whole self at a given time and can help to create internal order.

Mandalas can be used as tools for concentration and meditation; they can help us to get insight into and connections with our inner experiences. It's not unusual to see mandalas appearing in our dreams, our doodles, or our spontaneous drawings. Jung said that mandalas appear when we are experiencing anxiety, depression, or when we are feeling in conflict. Their purpose is to establish internal order. We can make mandalas spontaneously and intuitively, or we can learn different ways of making them.

Rock Art and Mandalas

According to archeological findings, the earliest art expression in our history was done between ten thousand and forty thousand years ago during the Stone Age. Some art may even date as far back as eighty thousand years ago. This prehistoric art was done in caves and on rocks, and it's known as rock art.

These man-made marks on natural stone have been found on all the continents but Antarctica, in different periods of our history. There are some places, Australia, for example, where rock art is still being made. It has been found in caves and rock shelters, in some outdoor settings, and also on "portable" rocks. Although it is called rock art, its initial purpose likely wasn't only as an artistic expression.

Rock art can be divided into *petroglyphs* and *pictograms*. Petroglyphs are carvings on rock; they are made by physically disturbing the stone surface by scratching, abrading, incising, etc. Pictograms are drawings or paintings on rock; they are made by applying pigments to the surface of the stone. Sometimes a third type of rock art is included, the *geoglyphs*, which are marks that are made by inscribing wet mud.

According to research, this early art form had many purposes. It was done for rituals and ceremonies, some probably related to the sun, the moon, and other natural cycles, such as day/night, seasons, birth/life/death, and menses and fertility cycles. Others may have been for luck when going to hunt, shamanic healing

ceremonies, magic rituals, spiritual and vision quests, etc. It was also made to mark or make note of special occasions and to record astronomical events like solstices and equinoxes, for maps and travel directions, and to mark resources like water. Some other theories say they could have contributed to the development of language, where images helped the early humans to communicate.

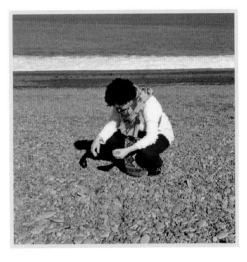

There are different forms of man-made marks on stone: naturalistic/realistic forms depict the real world, anthropomorphic or human beings, zoomorphic or animals, and plant forms. These marks range from very simple outlines to more detailed representations and stylized forms. Abstract marks have shapes that don't directly represent the real world, or don't represent reality in any way. These forms can also range from being very simple to being highly complex and can be stylized, too. A lot of geometric shapes are found in this group, including circles, spirals, dots, crosses, and concentric ripples, which are all basic forms of *mandalas*.

Meditation

A lot of my inspiration and color combinations come from my inner world. I see shapes and colors when I am falling asleep or waking up, when I'm daydreaming or meditating, when I'm having a shower, and when I'm intimate with my husband. Our mind produces symbols naturally; that's one of the functions of our unconscious. We all produce symbols. We need to learn how to see them and to let them out. We can also learn how to interpret them and find out what they mean.

One way of letting our images, colors, shapes, and mandalas out is by closing our eyes and letting our minds wander. I know, easier said than done. This simple meditation might help. You can read it first and then repeat it with your eyes closed, you can record it and then listen to it, or you can ask someone to read it to you. You can also try to do it with your eyes open while you read it. Choose a space that is comfortable for you, sitting on the floor or in a chair. Make sure you won't be disturbed for 15 to 20 minutes, so let people around you know what you're up to and turn off your phone. You can light a candle or a stick of incense, and you can use soothing music if you like.

Sit down comfortably, with your back straight, make the necessary adjustments to your position so you can relax, and close your eyes. Take a deep breath through your nose, hold it for a couple of seconds, and let the air out through your mouth slowly. Check your body for any tight muscles, and relax them with another deep breath.

See all the thoughts crossing your mind? Just let them flow...don't make any

judgment; just be a witness. Let your thoughts flow...don't try to stop them or get rid of them. *Let them be and then let them go...*

Now, let your thoughts be images...shapes...colors...

Look at them; register them in your mind...*let them go...*

Take a deep breath through your nose, hold it for a couple of seconds, and let the air out through your mouth slowly.

Pay attention to your body. Are there any sensations? Go from your head down to your toes, checking all of your body for any sensation. Do you notice any in particular? *Look at it...feel it...*

Now, let these sensations be transformed into shapes and colors.

Look at them; register the alignment in your mind...*now let them go...*

Take a deep breath through your nose, hold it for a couple of seconds, and then let the air out slowly through your mouth.

Pay attention to your feelings. How do you feel? Don't make any judgments; just be a witness. *Be with your feeling for a few seconds and then let it flow...*

Now, let your feelings translate into images...shapes...colors...

Look at them; register them in your mind. *Now let them go...*

Take a deep breath through your nose, hold it for a couple of seconds, and let the air out slowly through your mouth.

Let all the images, shapes, and colors blend together...

When you are ready, slowly open your eyes...

Let your hands express your experience...

Tools and Supplies

To start, you will need the supplies provided in the kit, plus acrylic ink. You can also try some of my favorite tools and supplies:

- Dip pen/nib holder with Hunt 512 Nib
- Round synthetic brushes, sizes 000, 1, and 2
- Faber-Castell Pitt artist brush pens in different colors
- Staedtler Black Pigment Fineliners or Faber-Castell Pitt artist pens (they are both waterproof and permanent)
- 4H Pencil (produces pale graphite lines)
- White colored pencil—Prismacolor 938 (invisible under the white ink)
- Daler-Rowney FW Acrylic Inks or Dr. Ph. Martin's Bombay India Inks
- Dr. Ph. Martin's Iridescent Calligraphy Ink: Copperplate Gold
- Golden Fluid Acrylic Paint: White
- Stones and pebbles

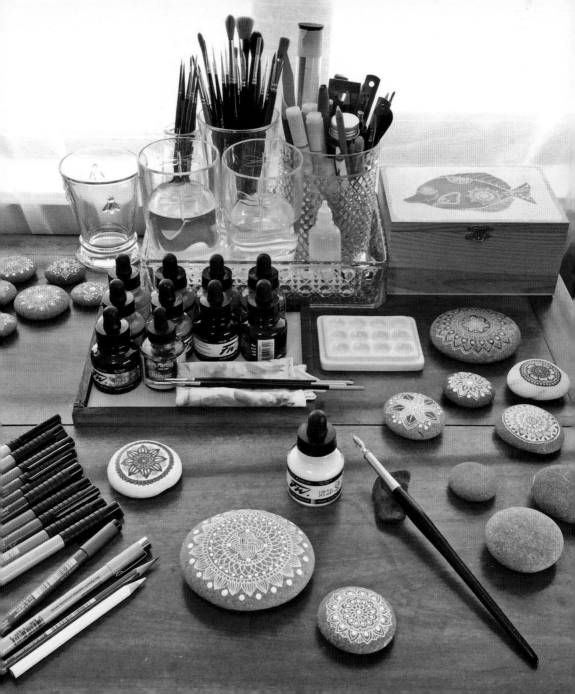

How to Draw a Mandala
Inspired by Mehndi Design

Mehndi is a Hindi word that means the art of temporary henna tattoos taken from the Sanskrit mendhika—or henna—plant.

This is an easy and fun way to draw mandalas. You only need paper and pens or a pencil of your choice. On this page, you will find some of the basic shapes to use when creating Mehndi-inspired designs. You can add more if you want—be creative!

Center Shapes

Fillings: Petals

Borders

Fillings: Leaves

Petals and Leaves

Embellishments

1. Choose the pens and colors you are going to use. You can choose to work in colors or monochrome.

2. Always start in the center and work outward so that the mandala can be kept fairly even. Begin with a spiral.

3. Now, create a border.

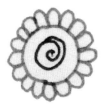

4. Draw petal shapes around the border.

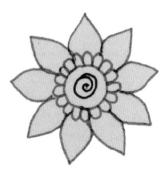

5. Add some filling to the petal shapes and then draw in leaves.

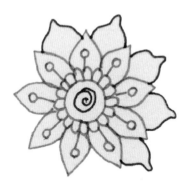
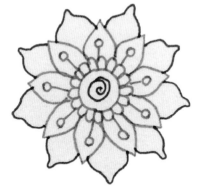

6. Now, add some filling to the leaves.

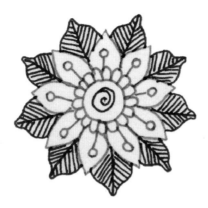

7. Add embellishments to the leaves and draw circles in the spaces between them.

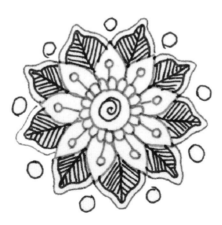

8. Draw another border.

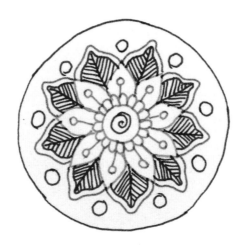

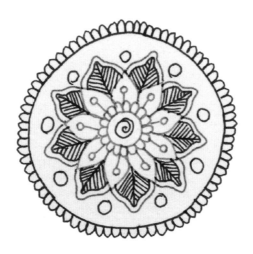

9. Draw in more leaves or petals and add more fillings.

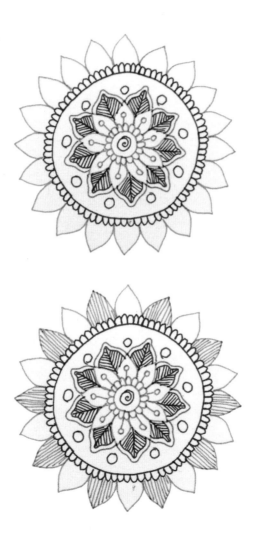

10. Finally, add some embellishments and little circles in the spaces between the petals and leaves.

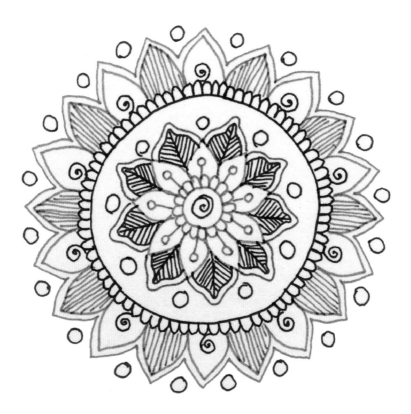

You can keep repeating the instructions from step 3 (on page 19), adding more elements from the basic shapes page or creating your own. Make your mandala as large and complex as you like.

When you feel you have finished your mandala, write the date at the bottom.

Look at your mandala with love. You just made it and it is precious!

It is fine if it doesn't come out perfectly round and symmetrical. You will get there with practice. It is a process to relax and have fun, regardless of the end result. Keep all your mandalas. Even if you don't like them much, you can follow how they change with time. Using the pages at the end of this book, collect a sketchbook of your designs. Keep practicing until you are confident enough to draw on a stone.

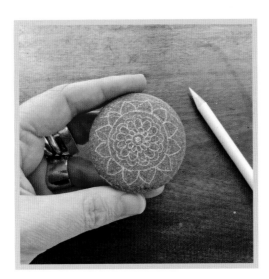

Hinduism-Inspired Mehndi and Kolam Mandala

This beautiful design is a wonderful place to begin using the simple steps starting on page 18. This is my favorite stone and I think of it as my signature project.

Technique

1. Wash the pebble in soapy water and let it dry.

2. Starting in the center, draw the basic design on the pebble using the white colored pencil.

3. Follow the instructions from How to Draw a Mandala inspired by Mehndi Design to create your design. Draw only the main lines; you can add the details later.

4. Using the dip pen or the brush, go over the basic design with white ink. Add all the details and let it dry.

5. Sign and date the reverse of your pebble and let it dry.

6. You can finish with a coat of varnish (optional).

NOTE: If your stone is too rough, you can start by applying a sealant or transparent gesso if you prefer. This makes the surface smoother to draw on. If the stone is too smooth, you can try sanding it first.

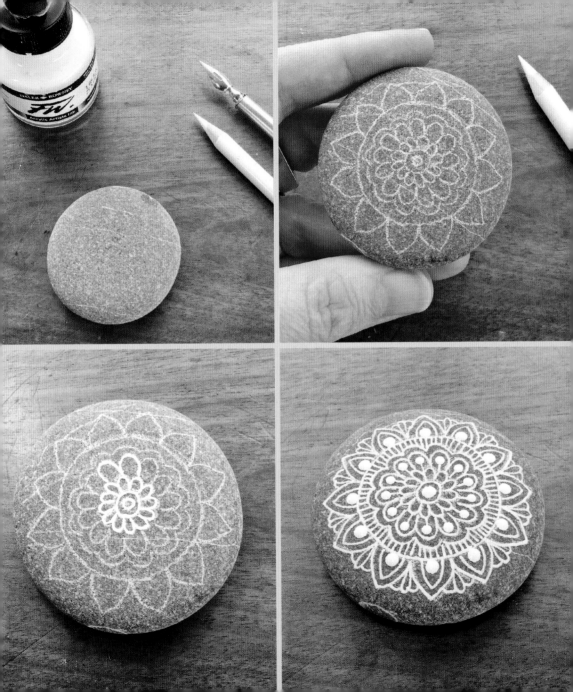

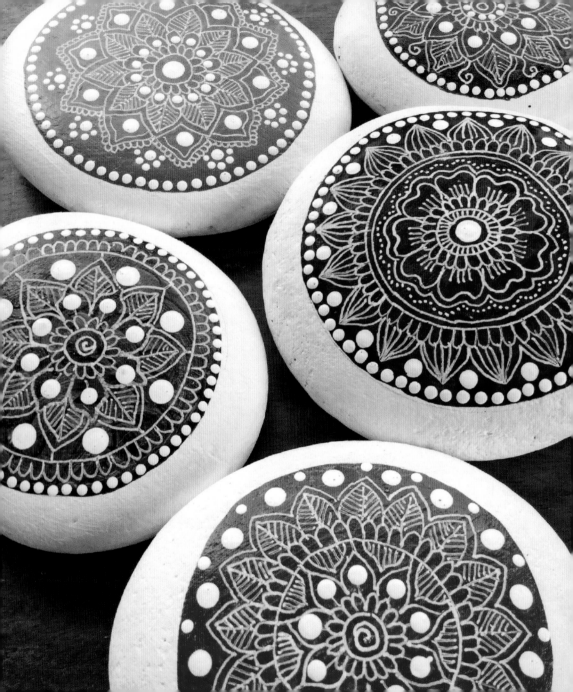

White Work Mandalas

This is another way to create a mandala using a beautiful pop of color against a background of white ink.

1. Wash the pebble in soapy water and let it dry.

2. Paint your stone with white acrylic paint and let it dry.

3. Paint a large colored circle with acrylic paint or acrylic ink.

4. Starting in the center, draw the basic design on the pebble using a white pencil.

5. Follow the instructions starting on page 18 from How to Draw a Mandala Inspired by Mehndi Design to create your design. Draw only the main lines; you can add the details later.

6. Using the metal nib or brush, go over the basic design with the white ink. Let it dry between steps.

7. Sign and date the reverse of your pebble and let it dry.

8. Finish with a coat of varnish (optional).

Mandalas in Color and Gold

This mandala design uses a vibrant metallic color to highlight the beautiful mandala shape.

1. Wash the pebble in soapy water and let it dry.

2. Starting in the center, draw the basic design on the pebble using a white colored pencil.

3. Follow the instructions starting on page 18 from How to Draw a Mandala Inspired by Mehndi Design to create your design. Draw only the main lines; you can add the details later.

4. Using the dip pen or the brush, go over the basic design with the white ink.

5. Add color with acrylic inks, and then add the outlines and details with gold acrylic ink. Let each color dry before you begin the next color.

6. Sign and date the reverse of your pebble and let it dry.

7. Finish with a coat of varnish (optional).

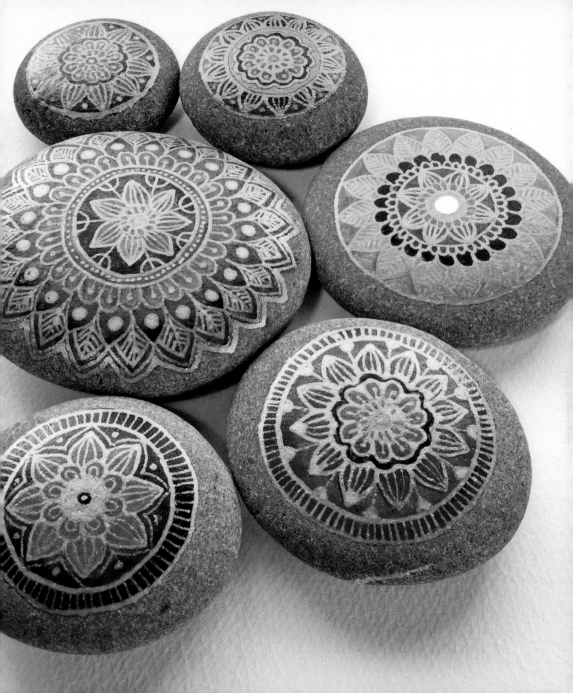

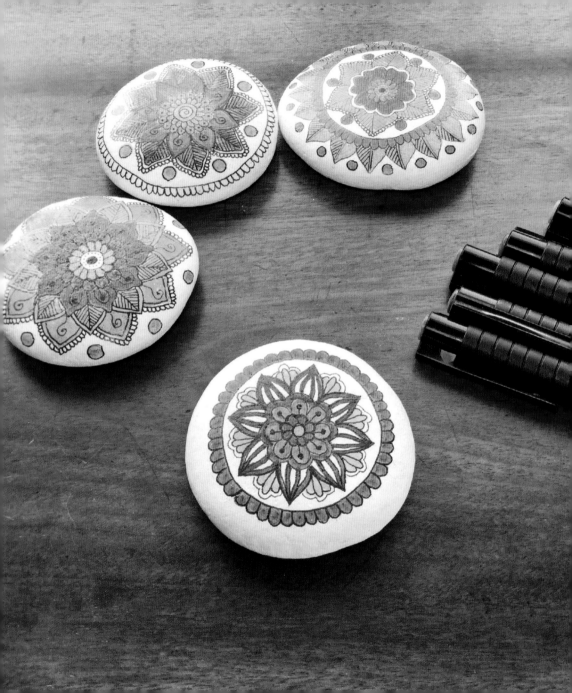

Colorful Mandalas

This is a fun way to create a fresh mandala design.

1. Wash the pebble in soapy water and let it dry.

2. Paint your stone with white acrylic paint and let it dry.

3. Starting in the center, draw the basic mandala on your white pebble using a pencil.

4. Follow the instructions starting on page 18 from How to Draw a Mandala Inspired by Mehndi Design to create your design. Draw only the main lines; you can add the details later.

5. Using a colored pen or the brush, go over the basic design with the colored inks. Let each color dry before you begin the next color.

6. Add the outlines and details with a black fine line marker.

7. Sign and date the reverse of your pebble and let it dry.

8. Finish with a coat of varnish (optional).

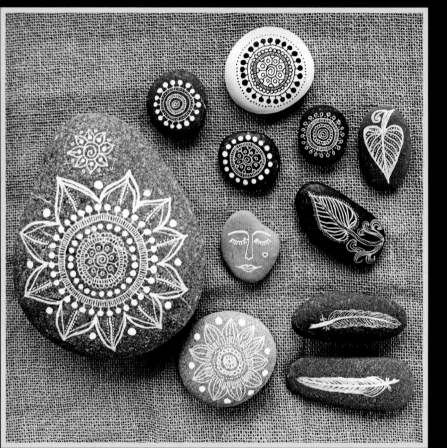

INSPIRATION
for Creative
and
Meditative Mandalas

Ancient Symbols:
Spirals, Dots, and Concentric Ripples

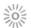

These abstract shapes, also referred to as geometric symbols or signs, are found in prehistoric rock art around the world. They are painted or engraved in caves and rock shelters and also on portable art objects. These shapes can also be found in modern art, children's drawings, and in our own doodles. They are universal.

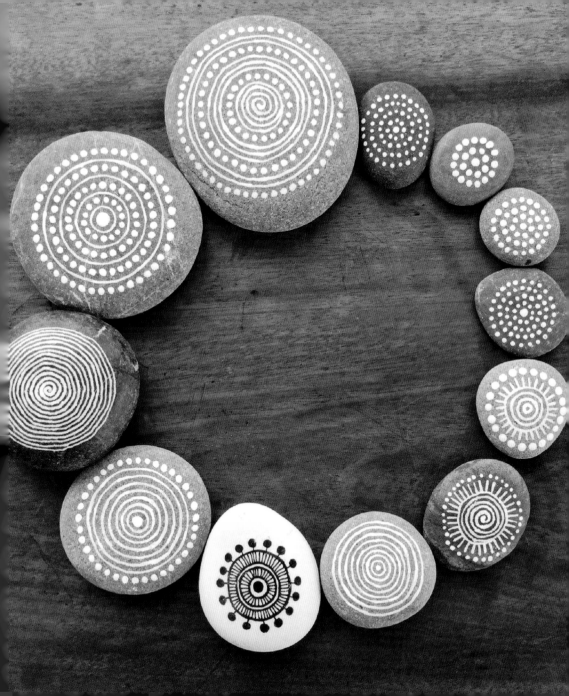

Koru: Maori Symbol of Growth, New Life, and New Beginnings

The Koru is a spiral design made by the Maori. It's inspired by the unfurling fern frond, possibly the silver tree-fern, which is endemic to New Zealand. It is found in Maori painting, tattoo art (tā moko), and carvings in green stone, bone, and wood.

It's the symbol of life and creation. The circular movement of the spiral symbolizes life's constant changes, while its inner coil represents going back to the beginning. The Koru can mean growth, new life, new beginnings, hope, and harmony.

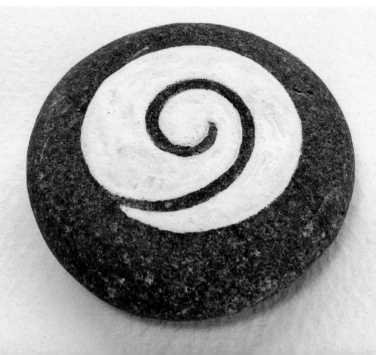

Judaism-Inspired
Star of David Mandala

I haven't been able to find mandalas in the traditional sense in Judaism in my readings; however, some details in synagogues, like their domes, some windows, and the kippah the men wear, can be likened to mandalas, as well as the Tree of Life in Kabbalah.

My inspiration for this mandala design came from the beautiful Shield of David or Star of David, which is the most recognized Jewish symbol.

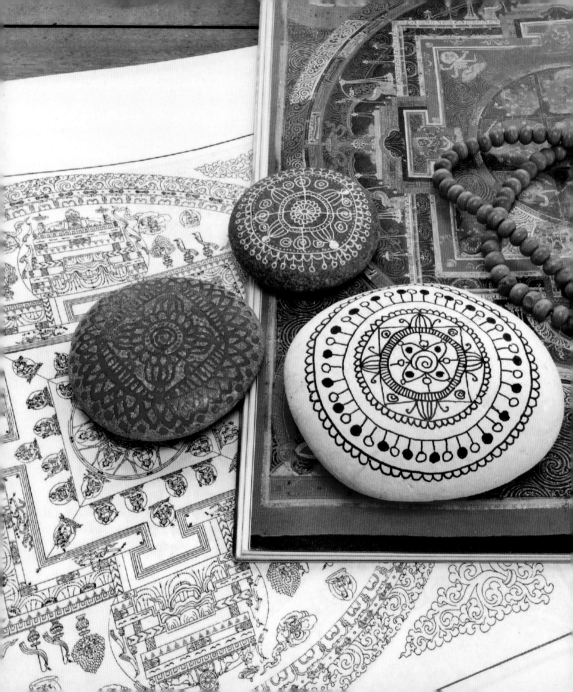

Buddhism-Inspired Four Gates Mandala

Some of the most well-known mandalas are those from Tibetan Buddhism. These mandalas, done by the Tibetan lamas, are often sandpaintings that take days to complete and then are destroyed as part of the ritual. This is to remind us of the impermanence of this world of samsara, the world in which karma operates.

These mandalas are maps of the cosmos; they represent the universe in its essential plan. They include many complex elements and symbols: an outer protective ring of fire around *vajras*; a band of lotus petals as the four cardinal points; and a fortress, castle, or palace with four gates in which the deity resides.

Christian Rose Window-Inspired Mandala

Rose windows, or wheel windows, are some of the mandalas found in the Christian tradition. They are circular windows found in churches, especially in Gothic cathedrals.

They probably have their origins in the Roman oculus, the circular opening in the center of a dome or wall, originally built to let in light and air. The wheel windows were originally simple, divided with just a few spokes radiating from a central stone or opening. Becoming more intricate and elaborate during the medieval period, they were made with stained glass, in more complex designs, and named rose windows because of their similarities with the rose flower and its petals.

The window is divided into 4, 8, 12, or 24 segments radiating from a central medallion, and its symbols include Christ seated in the center (the light), surrounded by the apostles, gospel writers, angels, saints, and others.

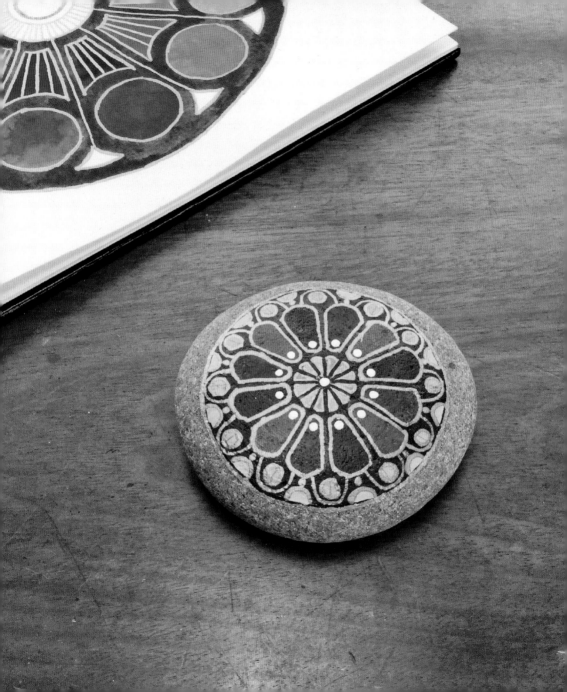

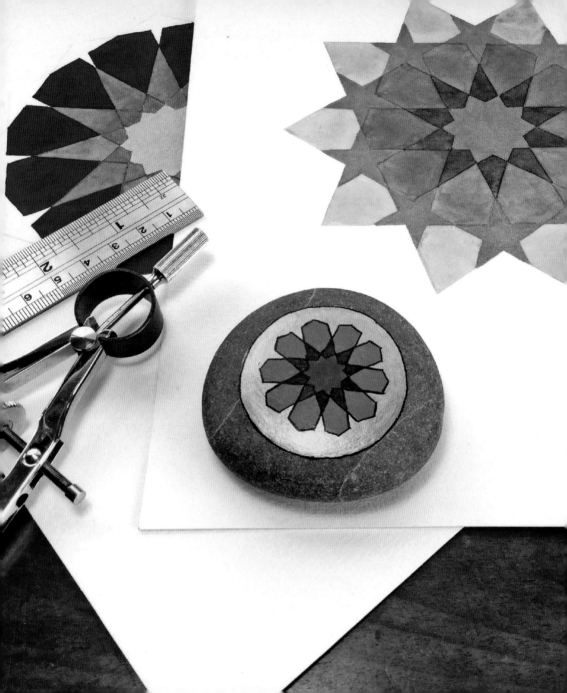

Islamic Geometric
Rosette-Inspired Mandala

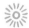

Geometry is one of the fundamentals of Islamic arts and crafts, as it has been for centuries in many cultures. It is not only important and practical for making things, but it also has a deep meaning in philosophy, cosmology, and some of the spiritual traditions. Geometric rosettes are the mandalas in Islamic art. Complex and beautiful, these geometric-constructed designs are mainly found in mosaics and parquetry, illuminations and miniature paintings, carvings, ceramic plates and tiles, and glasswork.

This pebble is the only one in this book that was not done freehand. It was inspired by a ten-fold rosette that I had previously constructed and then painted in watercolor. I scaled down the design for the pebble.

Inspired by Nature: White Mandala Flowers

For me, nature is a wonderful source of inspiration, particularly flowers. I like to draw and paint actinomorphic flowers; this means that the flower is radially symmetrical and can be divided into equal segments meeting at the center. They are gorgeous natural mandalas. I frequently draw my flowers in my journal before drawing them on the pebbles; sometimes I even paint them in watercolor and ink. I begin by drawing the basic, most predominant elements of the flower, such as petals and sepals. I then add some of the smaller features, and I even add some details of my own.

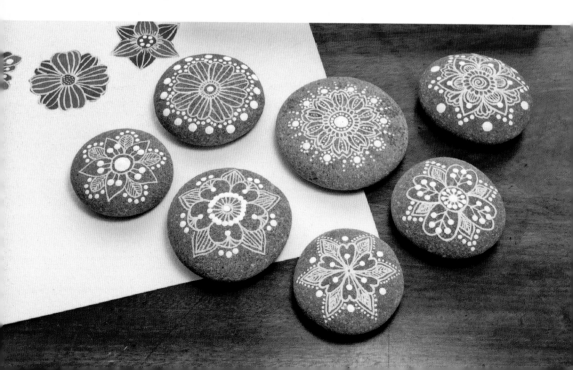

Inspired by Nature: Colored Mandala Flowers

lowers inspire me not only because of their shape, but also because of their colors.

Sometimes working with color and making color combinations can be intimidating, but we only have to look at how Mother Nature makes her colors sing and copy her combinations.

Black Work Mandalas

You can create many different mandalas using only a black pen. Black linework looks beautiful on natural white pebbles. White pebbles are not always easy to find. If you can't find them, you can paint your pebbles with white acrylic paint.

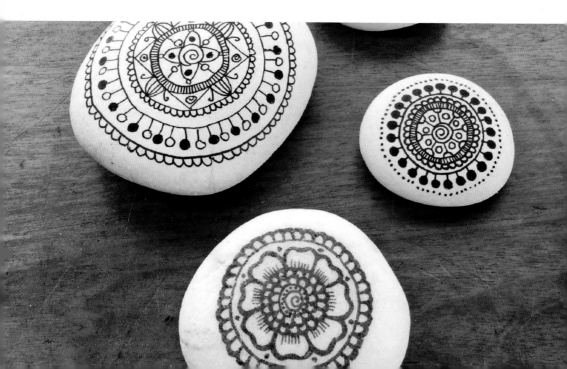

Animal Totem Mandalas

nimals are another element from nature that you can incorporate into
your mandalas. They are probably one of the most common elements
found in ancient and modern rock art.

You can use animals as symbols for qualities you want to express; they could be
your animal totems or a much-loved pet. I painted this stone after seeing it in one
of my meditations. Snakes, fish, and butterflies are frequently present in my art;
each of them has a special personal meaning.

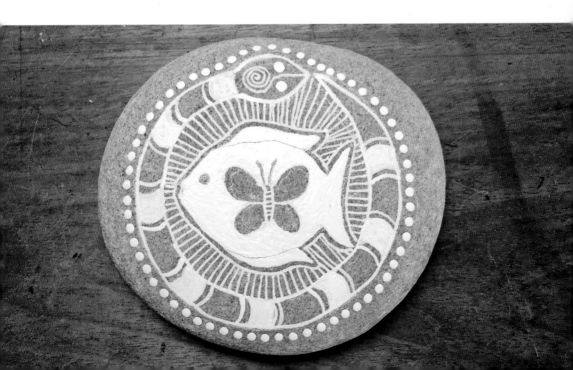

Sketch Your Mandala Designs

Use these pages to sketch and develop your own inspired mandala designs.

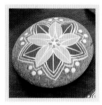

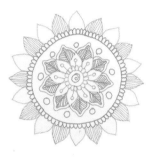

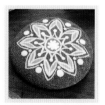

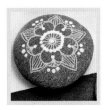

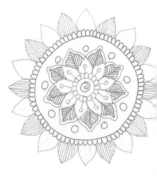

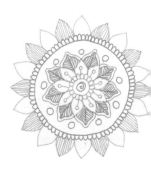

Sketch Your Mandala Designs

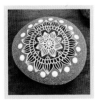

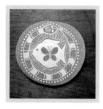

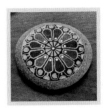

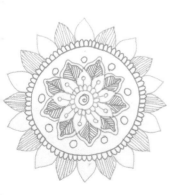

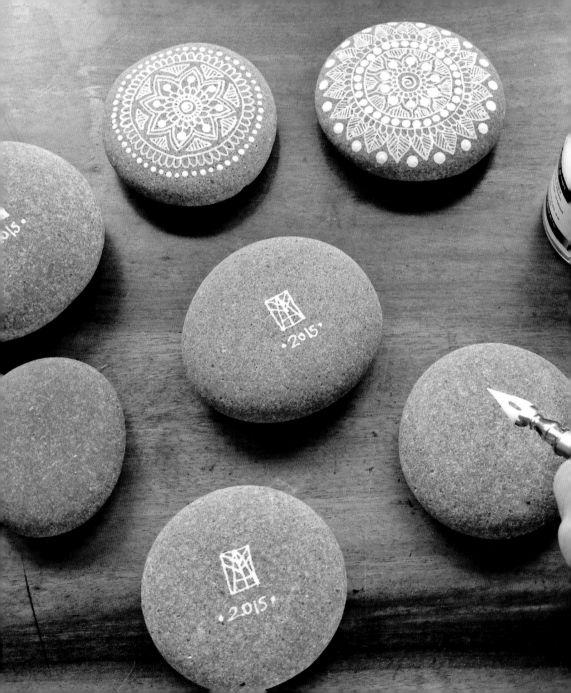

About the Author

I am Maria Mercedes Trujillo Arango, creator of the blog *MagaMerlina*. I'm a late-bloomer, self-taught illustrator-crafter from Bogotá, Colombia, who now calls New Zealand home. I haven't always been an artist. I attended medical school, became a psychiatrist, and decided to make art full-time in 2009. I sketch, draw, paint, and embroider. Mandalas have long been a theme in my work.

I began keeping art journals in 2001. Mandalas were a very frequent theme in my pages, so I started studying and learning about mandalas in different cultures, their history, psychology, and symbolism. I discovered that working with mandalas gave me endless possibilities, yet it gave me a frame: the circle. From my journals and mandalas, my art evolved. Mandalas have taught me about art, life, and myself.

The other part of my story is that I've always loved pebbles, rocks, and stones. I've been collecting them since I was a little girl. Around 1994, on a trip to Sweden, I saw some beautiful painted pebbles and I loved them. I had the idea of painting my own but never did. In 2011, during a trip around New Zealand, I collected some beautiful, round stones and immediately thought of drawing my mandalas on them. Since then, it's one of my favorite things to do.

You can see more of my work at www.magamerlina.com

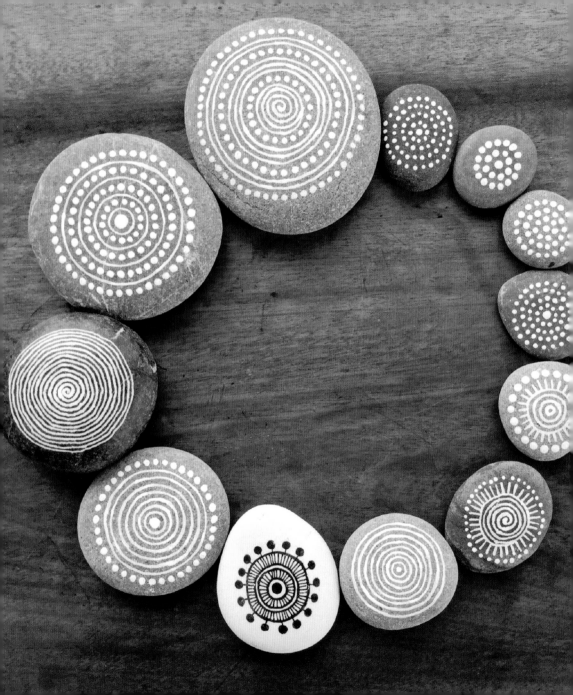

Further Reading

Some of my favorite books and writings about mandalas:

Arguelles, J. & Arguelles, M. *Mandala.*

Cornell, J. *Mandala: Luminous Symbols for Healing.*

Fincher, S. F. *Creating Mandalas: For Insight, Healing,
and Self-Expression.*

Hall, M.P. *Meditation Symbols in Eastern and Western Mysticism:
Mysteries of the Mandala.*

Jung, C. G. *Collected Works Vols. 9.1, 12, 13*

Jung, C. G. *Man and His Symbols.*

Jung, C. G. *Memories, Dreams, Reflections.*

Jung, C. G. *The Red Book.*

Kellogg, J. *Mandala: Path of Beauty.*

Micnhimer, D.R. *Understanding Meaning and Purpose of Rock Art.*

Tucci, G. *The Theory and Practice of the Mandala.*

Online Resources

creatingmandalas.com: Information on the history and psychology
of mandalas, ways to create and interpret your mandalas, etc.

100mandalas.com: A great place to start your mandala practice.

bradshawfoundation.com: A great resource to find information about rock art
around the world: research, news, glossary, psychology, bibliography, etc.

Inspiring | Educating | Creating | Entertaining

Brimming with creative inspiration, how-to projects, and useful information to enrich your everyday life, Quarto Knows is a favorite destination for those pursuing their interests and passions. Visit our site and dig deeper with our books into your area of interest: Quarto Creates, Quarto Cooks, Quarto Homes, Quarto Lives, Quarto Drives, Quarto Explores, Quarto Gifts, or Quarto Kids.

Text © 2016 Quarto Publishing Group USA Inc.
Photography © 2016 Maria Mercedes Trujillo Arango

First published in 2016 by Rock Point,
an imprint of The Quarto Group
142 West 36th Street, 4th Floor
New York, NY 10018 USA
T (212) 779-4972 **F** (212) 779-6058
www.QuartoKnows.com

Rock Point titles are also available at discount for retail, wholesale, promotional, and bulk purchase. For details, contact the Special Sales Manager by email at specialsales@quarto.com or by mail at The Quarto Group, Attn: Special Sales Manager, 401 Second Avenue North, Suite 310, Minneapolis, MN 55401, USA.

10 9 8 7 6

ISBN: 978-1-63106-233-9

Interior and Cover Design: Christine Heun

Printed in China